WITNEY
HISTORY TOUR

ACKNOWLEDGEMENTS

The images used in this publication were obtained from the Witney & District Museum and from the author's own collection.

First published 2017

Amberley Publishing
The Hill, Stroud,
Gloucestershire, GL5 4EP
www.amberley-books.com

Copyright © Stanley C. Jenkins, 2017
Map contains Ordnance Survey data
© Crown copyright and database right
[2017]

The right of Stanley C. Jenkins to be
identified as the Author of this work
has been asserted in accordance with
the Copyrights, Designs and Patents
Act 1988.

ISBN 978 1 4456 7318 9 (print)
ISBN 978 1 4456 7319 6 (ebook)

British Library Cataloguing in
Publication Data.
A catalogue record for this book is
available from the British Library.

Origination by Amberley Publishing.
Printed in Great Britain.

INTRODUCTION

Witney is a market town in the Oxfordshire Cotswolds that was, for many years, famous as a blanket manufacturing centre, although it also had a brewery, glove-making factories and, in more recent years, light engineering factories. This publication provides a brief illustrated history of the historic town. It is arranged in the form of a pictorial 'tour', starting with the church and Church Leys at the south end of the town, and working northwards via Church Green, Market Square and High Street to Wood Green. There are short diversions along Corn Street, Mill Street, West End and Newland, while the suggested route concludes with a look at Langal Common and the River Windrush.

The original village settlement grew up in a marshy area between divergent channels of the River Windrush – the first primitive village being sited on a low hillock known as 'Witta's Island' (or perhaps 'White Island'). Witney is first mentioned by name in Anglo-Saxon charters of 969 and 1044, which tell us that the manorial estate was owned by the Bishop of Winchester.

The Domesday Book suggests that, in 1086, Witney was a village of fifty-six households with a total population of perhaps 250. The manor contained 'two mills rendering 32s.6d', and there was a further mill in the adjacent manor of Cogges. However, it is likely that these mills would have been used for grinding corn, and there is no evidence that a specialised woollen industry had developed by early Norman times.

As lords of the manor, successive bishops of Winchester were able to influence the development of Witney in a variety of ways, and in the early thirteenth century a spacious 'new town' was laid out to the east of the earlier village. The medieval new town was aligned from north

to south, with lengthy burgage plots extending to the east and west of a wide marketing area, which later became Church Green, Market Square and High Street. Smaller building plots were created on each side of Corn Street, which diverged westwards from the Market Square. A further routeway, which later became Crown Lane, ran east towards the village of Cogges, with a market cross being erected at the junction of these streets and tracks. At its north end High Street merged into the present Bridge Street, Newland and West End. The whole settlement was surrounded by a drainage ditch known as 'Emma's Dyke', and in places the newly created burgage plots were artificially raised above water level.

Although Cogges is now regarded as an integral part of Witney, it was, in historical terms, an entirely separate parish. The Domesday Book reveals that in 1086 Cogges was held by a Norman called Wadard, although the estate later passed into the hands of another Norman family known as the d'Arsics, one of whom, Robert Arsic, laid out 'Newland' as a planned township along the Witney to Oxford road. Over time this new urban development became part of modern Witney – leaving Cogges Church, Priory and Manor Farm as a quaint and isolated group of old buildings on the edge of Witney.

By the end of the Middle Ages, Witney had grown into a prosperous market town with a population of around 1,000 and a slowly developing blanket industry – weaving being carried out in Witney, while domestic spinning was undertaken over a wide area of the Cotswolds. It is likely that Witney became a cloth-making centre as weavers sought to escape the restrictive guild regulations in old established 'industrial' towns such as Coventry. At the same time, the fast-flowing River Windrush was ideal for turning waterwheels and scouring broadcloth.

Witney had a population of around 1,800 at the time of the Civil War, when the town suffered at the hands of marauding Royalists. The local population was strongly Protestant and when, at the Restoration, the more extreme Puritans excluded themselves from the Church of England, Witney became a centre of Nonconformity with Quaker, Baptist and Independent congregations. In the eighteenth century, John Wesley paid

many visits to the town, and Methodism eventually became the dominant form of local Dissent.

Meanwhile, the blanket trade has gone from strength to strength, and by 1800 five mills were in operation in and around the town. The blanket industry was dominated by Nonconformists, most of whom were related to each other by birth or marriage. In 1711 the weavers obtained a charter of incorporation from Queen Anne in order that they could legally organise themselves into a guild or company for the better regulation of the industry. In 1721 the Company of Weavers erected a baroque 'Blanket Hall' in Witney High Street as their headquarters, and this building remained in use until the 1840s.

The blanket industry relied on water power for many years, mills such as Witney Mill and New Mill being sited at regular intervals along the River Windrush, so that water power could be effectively utilised. In the 1850s, New Mill was shared by John Early and Edward Early, while in the 1880s the mill was being used by Charles Early and his relatives Messrs Thomas & Walter Early. The opening of the Witney Railway in 1861 enabled coal to be transported to the town, and the first purely steam-driven mill was opened in Bridge Street in 1866.

By 1914 there were six mills in operation, divided between four main blanket-making firms: Charles Early & Co., William Smith & Co., James Marriott & Sons and Messrs Pritchett & Webley. The last named firm also had interests in a glove factory in Newland, and when Pritchett & Webley failed, the gloving business carried on as a separate concern. In 1933 a Yorkshire firm, James Walker & Son of Mirfield, opened another mill in the town, bringing welcome new employment to the town when other areas were suffering from the effects of the Great Depression.

In 1951 Witney became a centre of light engineering when Smiths Industries established a large factory on the site of Witney Aerodrome to the west of the town. The presence of Smiths and other industrial concerns ensured that, by the 1950s, Witney was no longer entirely dependent upon the woollen industry. Nevertheless, the town remained a famous blanket manufacturing centre until 2002, when the very last mill was closed.

KEY

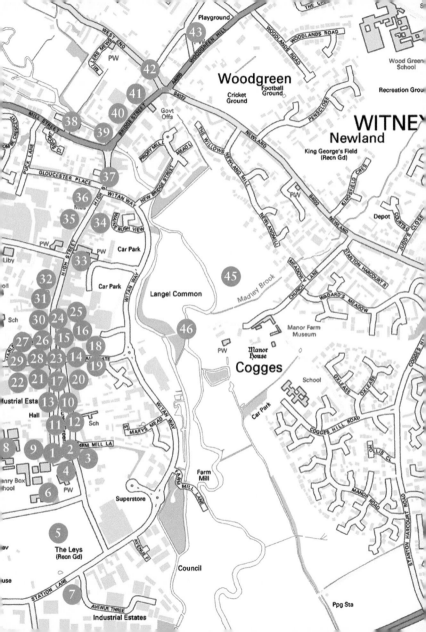

WITNEY

Newland

Woodgreen

Cogges

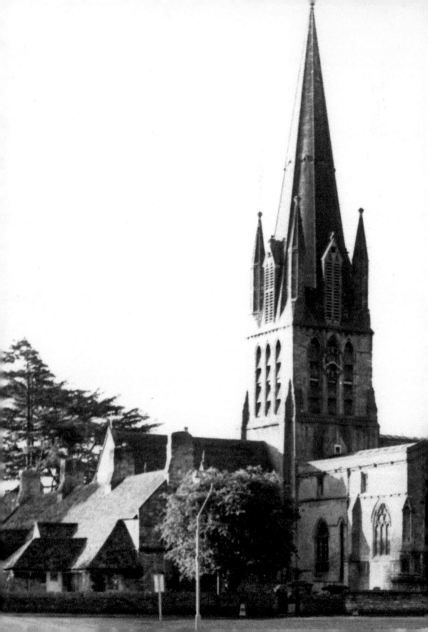

1. ST MARY'S CHURCH

St Mary's Church is a cruciform structure measuring approximately 130 feet from north to south and 130 feet from east to west, while the tower has a height of 156 feet. Blocked round-headed windows in the nave suggest that the first church, which was probably erected during the eleventh century, comprised a nave and chancel, while the north aisle, with its Norman doorway, was a twelfth-century addition. The church was enlarged during the thirteenth century, when it acquired transepts and a new chancel.

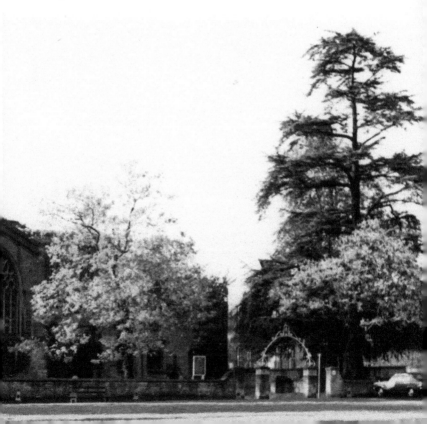

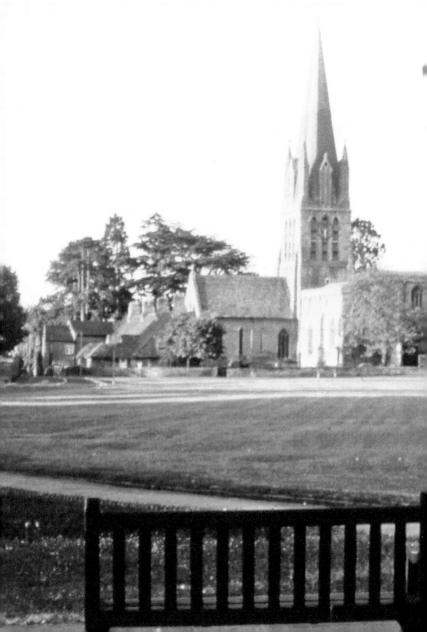

2. ST MARY'S CHURCH & CHURCH GREEN

St Mary's Church as seen from Church Green. It is assumed that the central tower, with its magnificent Early English spire, was added during the thirteenth century, although the ringing chamber within the tower contains an unusual mural passage that is pierced by Saxon-style triangular-headed openings – a possible indication of much greater antiquity. On 2 September 1942 the spire was hit by a Miles Master aircraft, which crashed into a nearby garden, the pilot and a passenger being killed, although a Hotspur glider that was being towed at the time landed safely on nearby Cogges Hill.

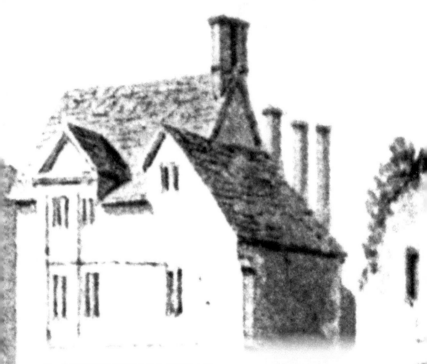

3. WITNEY 'CASTLE'

Around fifty years after the Norman Conquest, the Bishop of Winchester erected a stone-built manor house at Witney in convenient proximity to the parish church. A later bishop, Henry de Blois (*c.* 1096–1171), transformed the house into a walled and moated 'castle', with a gatehouse and characteristic Norman tower keep – the fortifications being added during the period of civil war between King Stephen and the Empress Mathilda. The civil war ended in 1153 and, thereafter, the manor house reverted to its original role as the headquarters of a manorial estate. The foundations of the tower keep can still be seen.

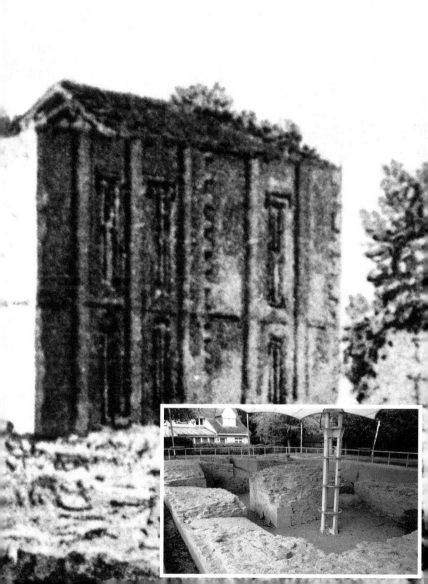

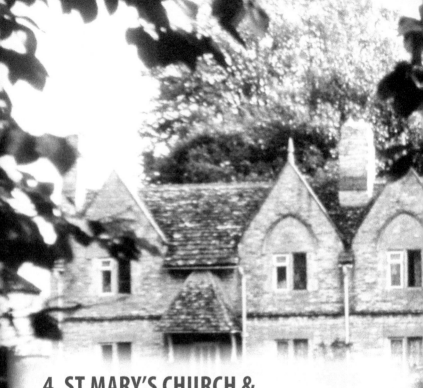

4. ST MARY'S CHURCH & HOLLOWAY'S ALMSHOUSES

Witney has three rows of almshouses, including these picturesque old buildings in the churchyard, which were bequeathed to the town by John Holloway in 1724 and reconstructed by the Witney architect William Wilkinson (1819–1901) in the 1860s. The churchyard contains the grave of Sergeant-Major Patrick Moulder (*see* inset), the landlord of the Cross Keys Inn and RSM of the Oxfordshire Yeomanry Cavalry, who had served in the 15th Hussars during the Napoleonic War and was present at the battles of Corunna, Vittoria, the Pyrenees, Orthes, Toulouse and Waterloo.

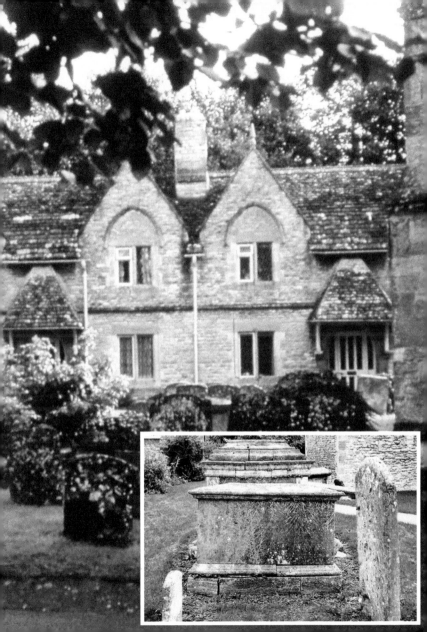

5. THE CHURCH LEYS – THE EAST SIDE

At the end of the First World War, a War Memorial Committee had wanted to commemorate Witney's fallen heroes by erecting a cottage hospital. The committee hoped to raise £12,000 but the target figure was not reached so, as an alternative, it was decided that the Church Leys recreation ground would be purchased from the Church of England for the sum of £1,027 2s so that it would become a memorial to those who had lost their lives during the 1914–18 conflict.

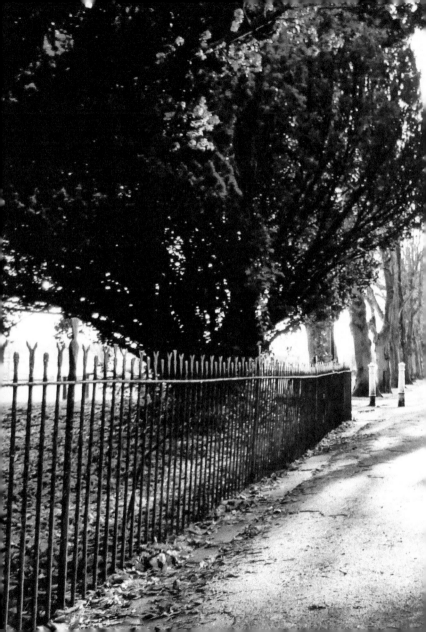

6. BATT'S WALK

Witney's first railway station, on the east side of the Leys, had been opened by Witney Railway in 1861, but in 1873 a new passenger station was brought into use on a more southerly site that was somewhat further from the town centre. On 5 December 1872 *The Witney Express* reported that 'a new footpath had been laid across the Leys', with young trees planted on either side 'following a suggestion by Dr Batt'. A direct means of access was thereby created for pedestrians between the new station and the town.

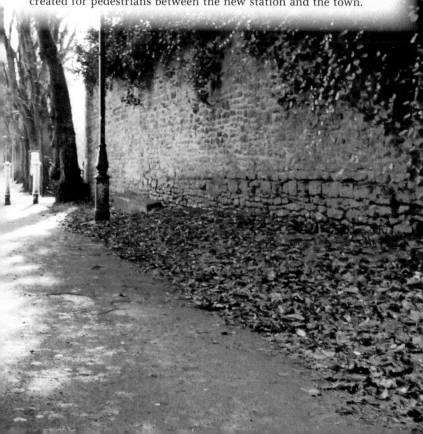

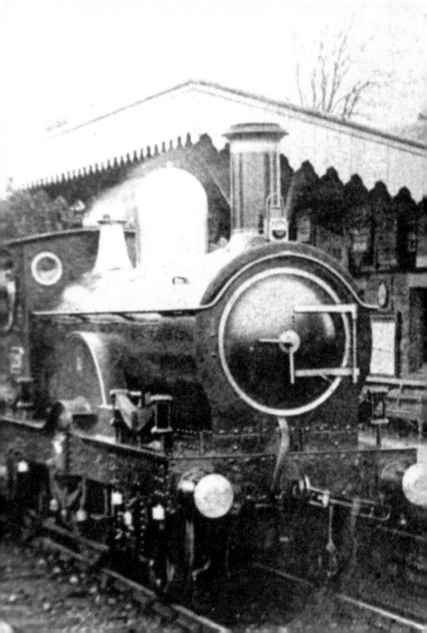

7. WITNEY PASSENGER STATION

As mentioned on the previous page, the railway reached Witney in 1861, but the line was extended to Fairford in 1873 and the original station was then used exclusively for goods traffic – a new station being opened for passenger traffic. The accompanying photograph shows a Great Western 2-2-2 locomotive entering the passenger station with an up train around 1910. Witney station was closed to passengers on 16 June 1962, but the line was retained for goods traffic until November 1970.

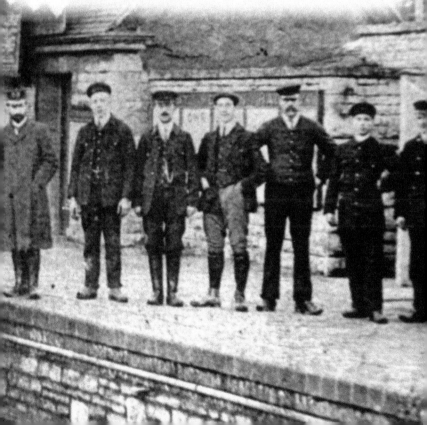

8. WITNEY GRAMMAR SCHOOL, CHURCH GREEN

Witney Grammar School was founded in 1660 by Henry Box (1585–1662), who had made his fortune as a businessman in the City of London and wished to endow a grammar school in his native town. The 'very fair schoolhouse', which was under construction by 1660, is one of the finest vernacular buildings in Witney, its distinctive yet dignified appearance reflecting the architectural taste of the Commonwealth period. Girls were first admitted in 1904, and in 1969 this historic school became a non-selective comprehensive known as 'The Henry Box School'.

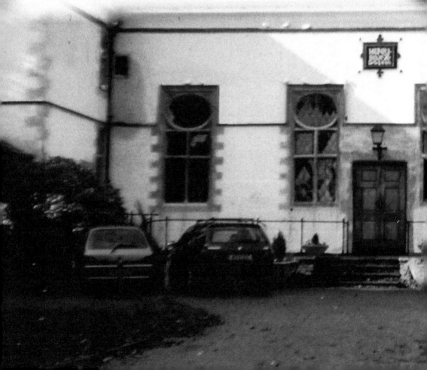

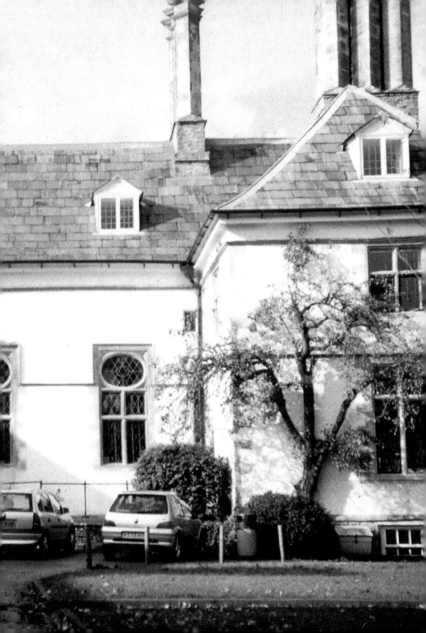

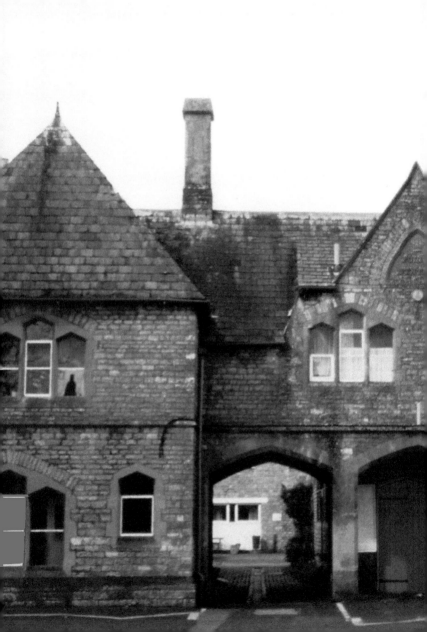

9. THE OLD POLICE STATION, CHURCH GREEN

Witney's first purpose-built police station was designed by William Wilkinson and erected in 1860, the contractor being Malachi Bartlett (1802–75) of Witney. The new building, which replaced an earlier police 'lock-up' at No. 33 Market Square, incorporated residential accommodation for an inspector and sergeant, as well as offices, cells, a courtroom and other facilities. The building was later used by the county educational authorities following the opening of a new police station in Welch Way.

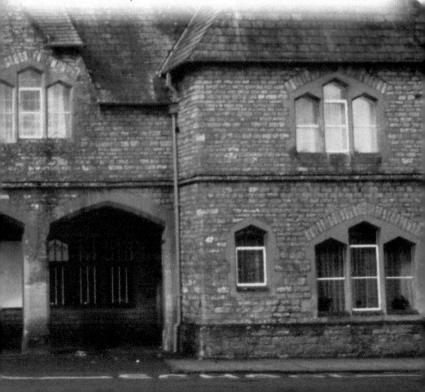

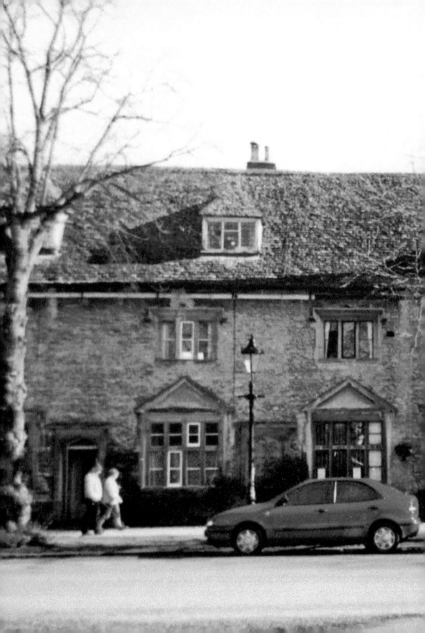

10. THE HERMITAGE, CHURCH GREEN

Nos 3–5, 'The Hermitage', a Tudor building on the east side of Church Green, is clearly one of the oldest domestic buildings in Witney, its ornate façade being dated '1564'. When first constructed the building would have contained a centrally placed hall, but this large room was later subdivided. The Hermitage is said to have been used as plague retreat by the Fellows of Merton College in 1665, while in 1916 it housed a 'Young Men's Social Club'.

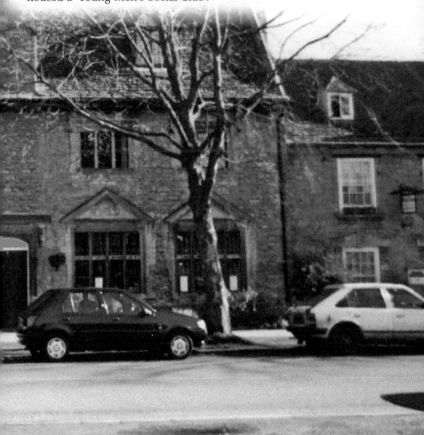

11. WARTIME BOMB DAMAGE, CHURCH GREEN

On the night of 21–22 November 1940 Witney was hit by two bombs, one of which landed on Church Green while the other exploded behind the Eagle Brewery. The bombs caused blast damage to the Grammar School and to many of the houses on Church Green, while falling glass from the roof of the weaving sheds at nearby Mount Mill severed the 'warps', and production was halted while the 'chains' of warp were replaced. The damaged houses were soon repaired (*see* inset).

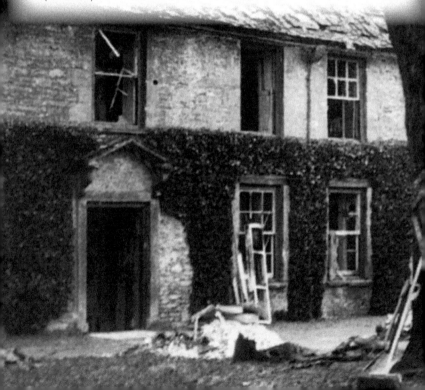

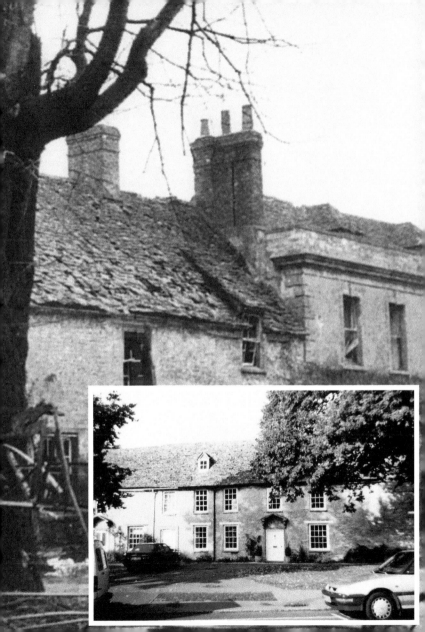

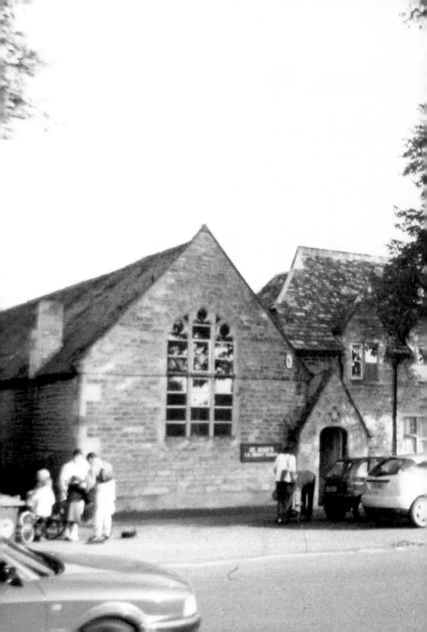

12. ST MARY'S CHURCH OF ENGLAND SCHOOL, CHURCH GREEN

The development of universal elementary education in the nineteenth century resulted in the establishment of both national (Anglican) and Wesleyan schools, the national school being founded at a meeting held in the Blanket Hall in 1813. A small school was subsequently opened in Bridge Street, while in 1836 a separate infants' school was established by the rector of Witney, Revd Charles Jerram, at his own expense. The two schools were subsequently merged to form St Mary's Church of England School on Church Green, which was housed in a picturesque Victorian building dating from around 1860. St Mary's is now a Church of England infants' school.

13. THE WAR MEMORIAL, CHURCH GREEN

In addition to purchasing the Leys, the Witney War Memorial Committee erected a dignified memorial cross on Church Green, which was inscribed with 157 names and dedicated at a well-attended open-air service held on 19 September 1920. A further thirty-five names were added to the memorial after the Second World War. The memorial was designed by the Oxford-based architect Thomas Rayson (1888–1976), who had been employed by the Office of Works as the site engineer at Witney aerodrome during the First World War.

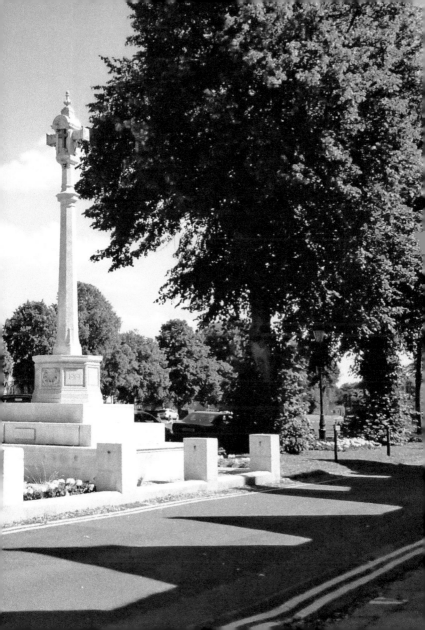

14. THE BUTTERCROSS, MARKET SQUARE

The famous Witney Buttercross was originally a religious shrine, but after the Reformation it was adapted for use as a covered 'market house'. The gabled roof is thought to have been added in the early seventeenth century following a bequest from Richard Ashcombe, a gentleman of Curbridge, who in 1606 left £50 to the bailiffs of Witney to be 'bestowed and layed-out in the building of an house over and above the Crosse of Witney'. The clock, with its tiny baroque cupola, was added in 1683 by William Blake of Cogges.

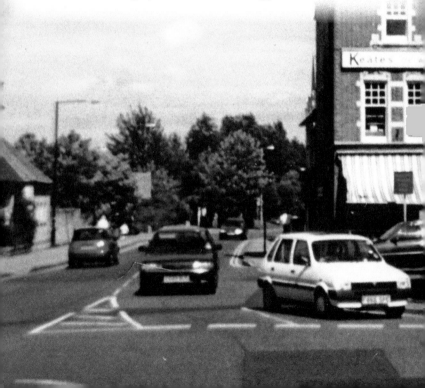

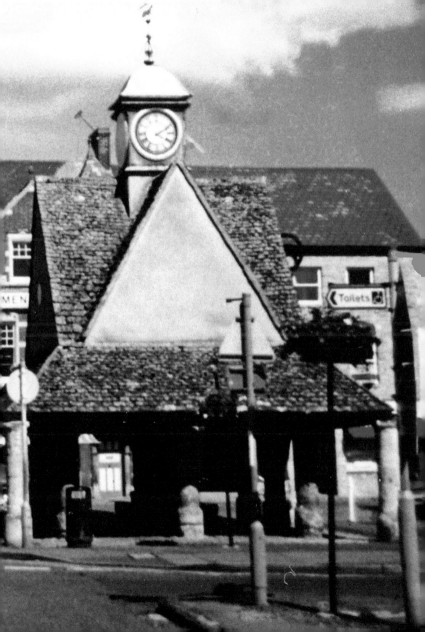

15. THE BUTTERCROSS, MARKET SQUARE

The Buttercross, looking north-east, probably around 1920. No. 29 Market Square, to the right of the picture, was A. H. Rowley's clothes shop, while No. 25, the tall building that features prominently to the left of the Buttercross, housed the Pearl Assurance Co. At that time the Buttercross featured ornate timber gables, but these were subsequently replaced by plain rendered gables, as shown in the previous photograph. Rowley's has now become Keates' outfitters, while Nos 27 and 25 have been demolished.

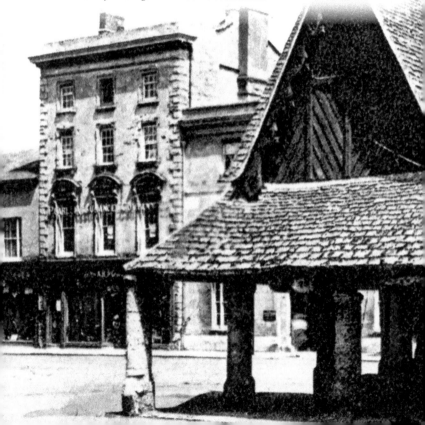

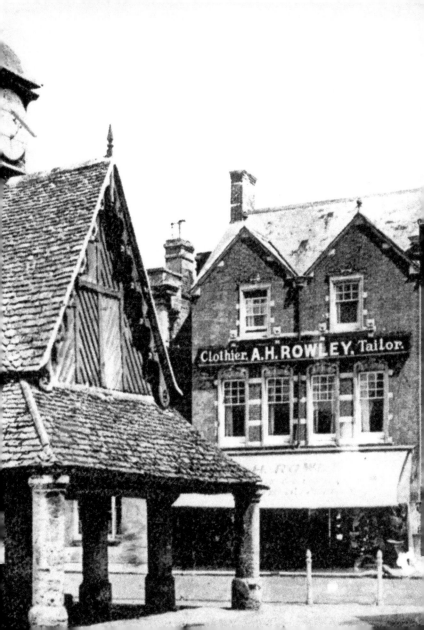

16. THE BUTTERCROSS & TOWN HALL, MARKET SQUARE

A further view of the Buttercross and the neighbouring town hall, looking northwards in February 2013. The latter building, which replaced a much earlier town hall on the same site, dates from around 1786 and is said to have been designed by Sir William Chambers (1722–96), who also designed Woodstock Town Hall. It incorporates a council chamber over an open loggia, the upper floor being supported on Tuscan columns.

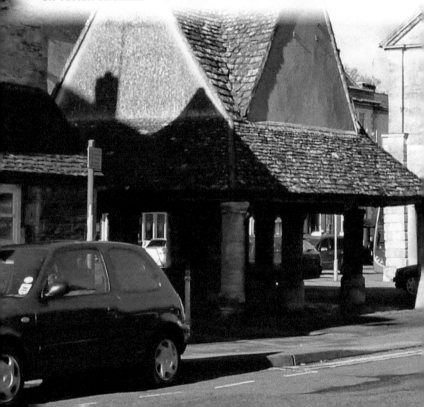

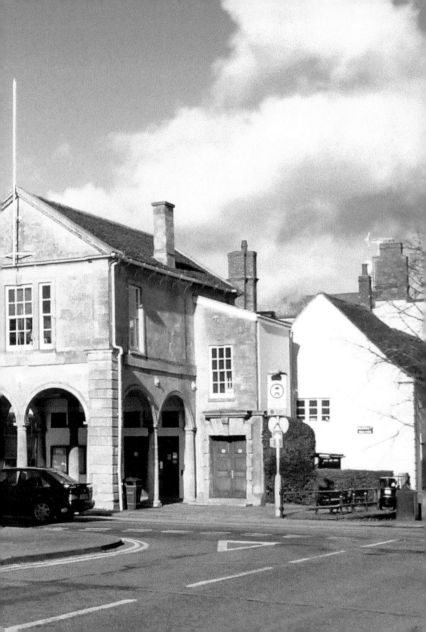

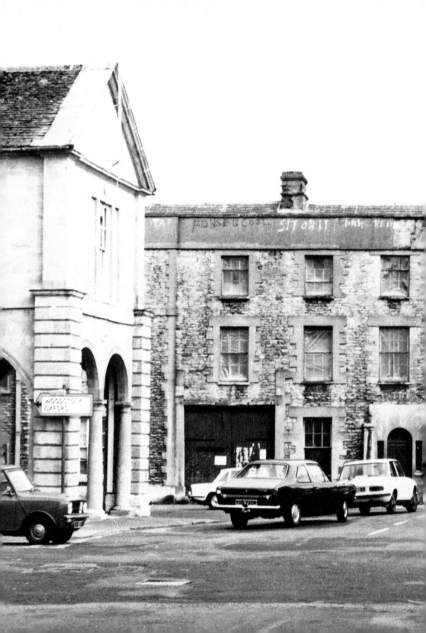

17. THE CROWN HOTEL, MARKET SQUARE

No. 27 Market Square, the former Crown Hotel, was important during the stagecoach era. In its heyday this three-storey building was rendered with plaster and colour washed, while the large gateway to the left of the doorway enabled vehicles to reach stables at the rear of the property. The Crown ceased to be an inn in the 1850s, but it remained a prominent feature of Witney until the 1980s when, despite sustained protests, it was demolished to make way for the present 'Langdale Gate' road.

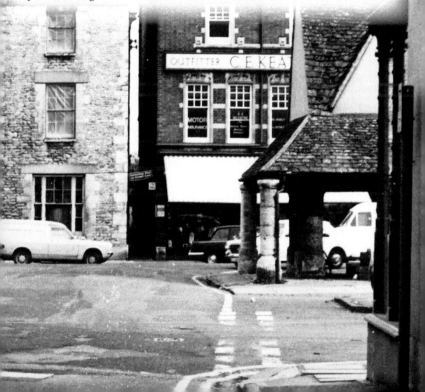

18. CROWN LANE LOOKING EASTWARDS, MARKET SQUARE

Until the untimely demise of the Crown Hotel, Crown Lane had provided a pedestrian link between Market Square, Langal Common and Cogges. The aperture between Keates' shop and the Crown was exceedingly narrow, but the path was nevertheless well used by walkers and cyclists. The scene was utterly transformed by the construction of Langdale Gate during the 1980s – the name chosen for this new road being somewhat confusing, insofar as there has never been any kind of gate at this point!

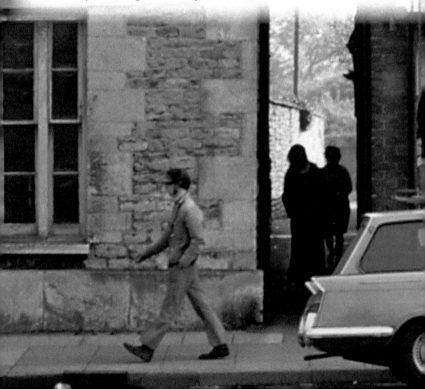

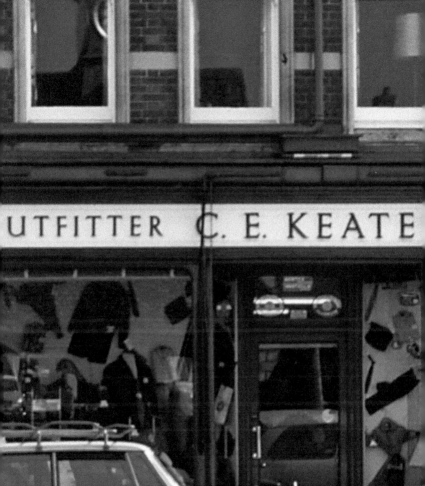

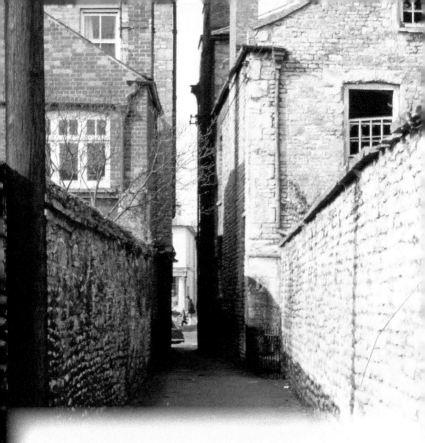

19. CROWN LANE LOOKING WESTWARDS, MARKET SQUARE

Crown Lane, looking west towards Market Square during the early 1970s. Although Langdale Gate has totally obliterated the western end of Crown Lane, the eastern section of this narrow lane has remained in situ as a pedestrian pathway, which provides a direct link between Market Square and Langal Common.

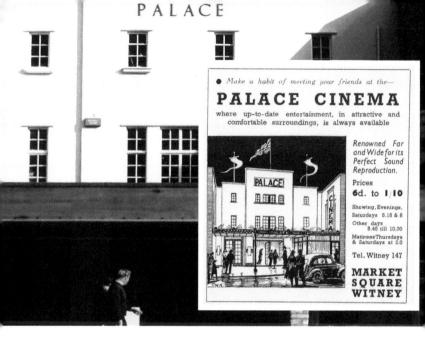

20. THE PALACE CINEMA, MARKET SQUARE

'The Electric Theatre' was opened at No. 31 Market Square around 1913. Its name was soon changed to 'The People's Palace', and then to 'The Palace Cinema'. The cinema was rebuilt in the art deco style during the 1930s, the main façade being set back from the pavement to make room for an open-fronted forecourt or loggia. Internally, the auditorium consisted of a large hall with a balcony and a gently sloping floor, the 'tip-up' seats being divided into two blocks by an off-centre aisle. The cinema was closed in the mid-1980s, and the building was used as a health club before becoming a nightclub. The former cinema was reopened as a J. D. Wetherspoon pub on 21 February 2012.

21. THE ANGEL & THE BULL, MARKET SQUARE

A detailed view showing some of the old Cotswold stone buildings on the west side of the square, including No. 46 The Bull and its near-neighbour, the Angel, No. 42. The intervening property, No. 44, was Messrs Saltmarsh & Druce – a well-established grocery business. The Bull is now used as offices and a bookshop, while Druces' has become a Thai restaurant, although the Angel is still functioning as a popular town centre pub, offering food and a choice of real ales.

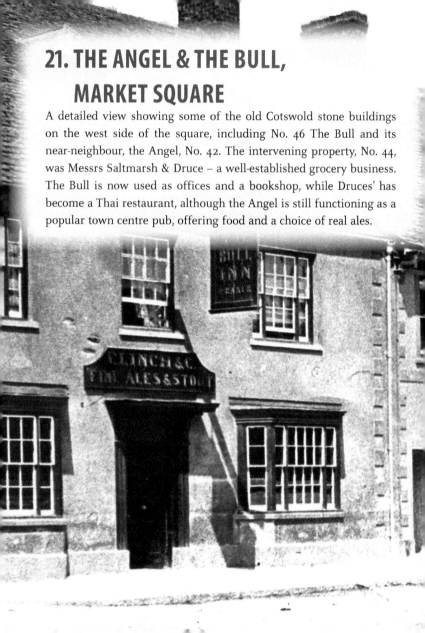

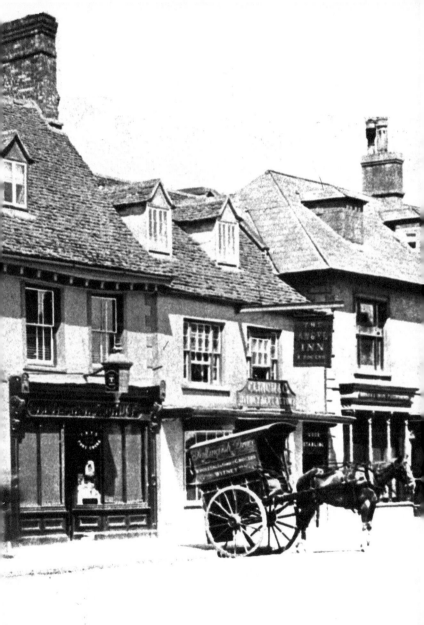

22. CLINCH'S EAGLE BREWERY, MARKET SQUARE

In the 1830s John Williams Clinch (1787–1871) and his brother James Clinch (1788–1867) established Clinch's 'Eagle Brewery' on an extensive site to the west of Church Green. Completed around 1840, the brewery incorporated a large malthouse and an impressive four-storey brewing tower with a tall stone chimney stack. The brewery was taken over by the Courage combine in 1963 and brewing in Witney ceased. The main building was subsequently demolished to make room for the Eagle Industrial Estate, although a microbrewery was later set up in one of the units, and after many vicissitudes this new venture became the Wychwood Brewery.

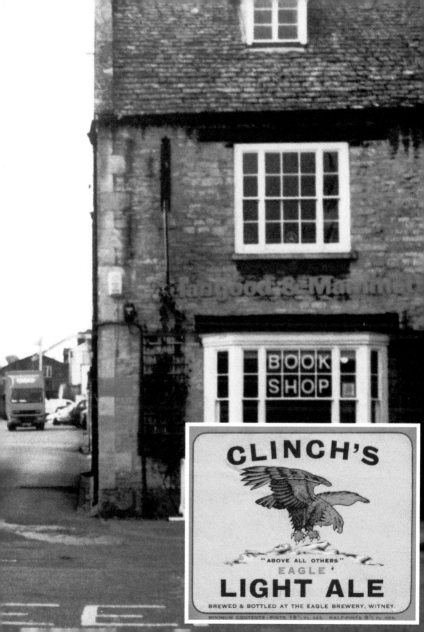

BOOK
SHOP

CLINCH'S

"ABOVE ALL OTHERS"
EAGLE
LIGHT ALE
BREWED & BOTTLED AT THE EAGLE BREWERY, WITNEY.

MINIMUM CONTENTS: PINTS 19½ Fl. OZS. HALF-PINTS 9½ Fl. OZS.

23. TARRANT'S CORNER, MARKET SQUARE

Witney lost many interesting and attractive buildings during the 1960s and 1970s when local politics were dominated by protracted, acrimonious and expensive planning disputes between the local authorities and bodies such as the Council for the Preservation of Rural England. The attitude displayed by the local council was exemplified by the destruction of W. H. Tarrant's former shop and warehouse on the corner of Corn Street and Market Square, which was replaced by a slab-sided structure of almost unbelievable ugliness.

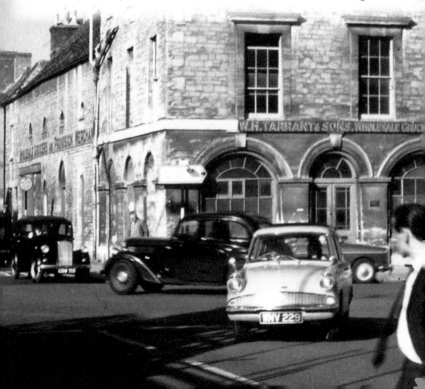

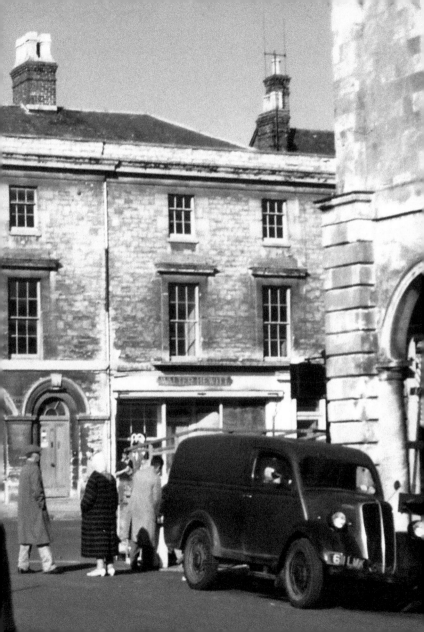

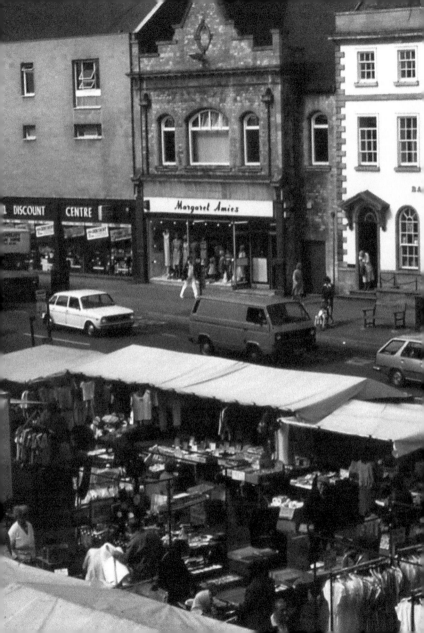

24. MARKET DAY & THE MARLBOROUGH HOTEL, MARKET SQUARE

A market in progress in Market Square around 1976. The Marlborough Hotel, No. 28 Market Square, can be seen in the background, together with No. 30, formerly Gilletts Bank and now Barclays. Tarrant's wholesale warehouse is no more, but No. 32, W. H. Tarrant & Sons's former grocery store, with its ornamental gable, has now been incorporated into Barclay's Bank. The gateway at the right-hand end of the Marlborough gives access to Marlborough Lane. The Marlborough has now been renamed 'The Blue Boar'.

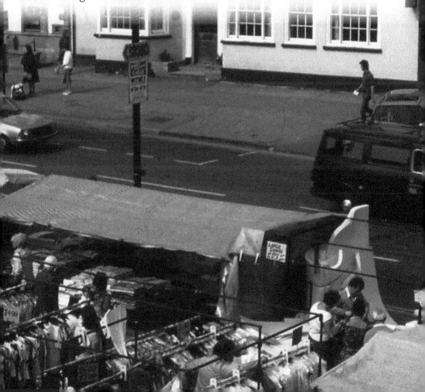

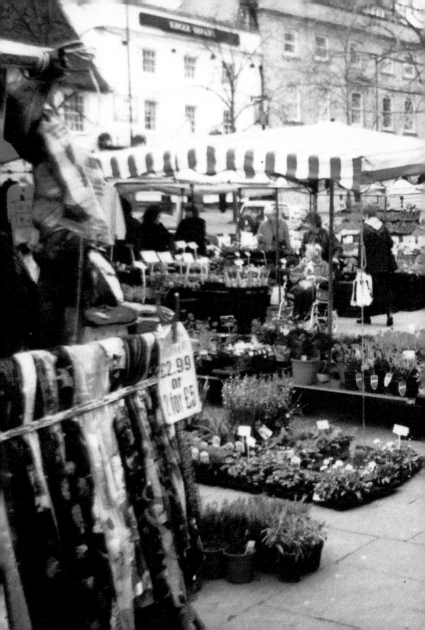

25. MARKET SQUARE

A final glimpse of Market Square on a typical market day. The cattle market was held in the square for many years, but it was later moved to a new site at the rear of the Corn Exchange. Cattle markets are no longer held in Witney.

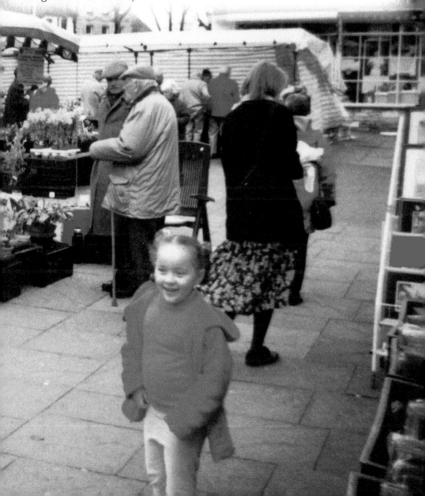

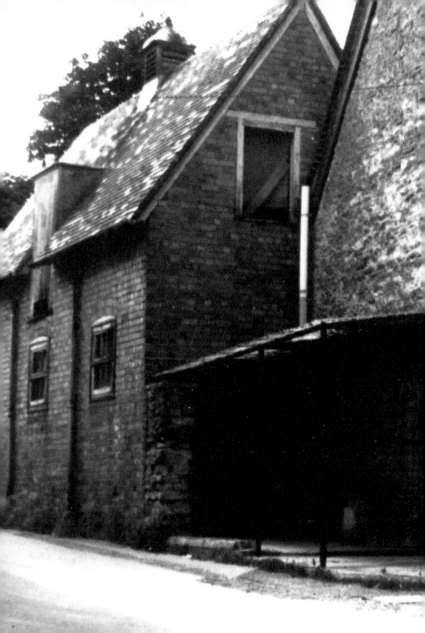

26. THE INDEPENDENT CHAPEL, MARLBOROUGH LANE

Marlborough Lane, which provides a link between Market Square and Corn Street, was originally known as 'Meeting House Lane' – an Independent chapel having been erected in 1712. Its first minister was Samuel Mather, a nephew of Samuel Mather of Harvard University, and the favourite preacher of Henry Cromwell when he was serving as Lord Deputy of Ireland. The chapel, now a Scout hut, was a simple, barn-like building with a gabled roof. It was entirely devoid of decoration, although there were three memorial tablets to people who had been buried within the building.

27. THE WITNEY AXE MURDER, MARLBOROUGH LANE

A further view of Marlborough Lane, looking east towards Market Square, the old Meeting House being visible in the distance. The cottage on the extreme left was the scene of a murder that took place on Sunday 30 July 1871 when Edward Roberts (also known as Ned Robbins) struck thirty-three-year-old Ann Merrick on the back of the head with a hatchet, causing a 4.5-inch gash that exposed her brain. The unfortunate victim died from her injury some four weeks later and, having been convicted of murder, Edward Roberts was hung at Oxford Castle on 18 March 1872.

28. THE EAGLE TAVERN, CORN STREET

Corn Street, looking west around 1975. In architectural terms, this street has changed very little in recent years, although individual traders have come and gone. The building with the blue-green rendering is No. 22, the Eagle Tavern, which was the last Witney pub to retain its traditional layout of two small bars and a connecting passage with benches for children to sit on. Gordon Rollins, who ran the Eagle from the 1950s until 1999, was Witney's longest-serving landlord.

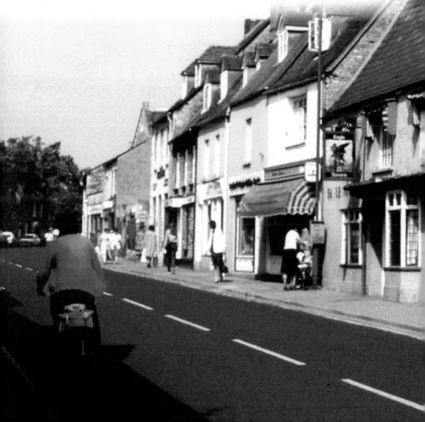

29. THE PRIMITIVE METHODIST CHAPEL, CORN STREET

Corn Street, looking east towards the Buttercross, with the Primitive Methodist chapel visible to the left. The Primitive Methodists were founded by Hugh Bourne, a Staffordshire millwright, during the early nineteenth century. A Primitive Methodist chapel was in existence in Witney by 1845, and this became a Sunday school following the erection of a new chapel in 1869. The chapel became a launderette in the 1960s, but it is now used as a 'deli' bar and barber's shop.

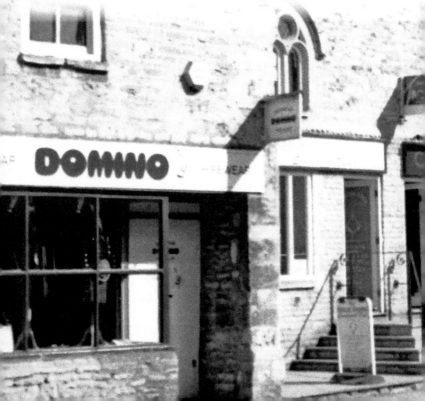

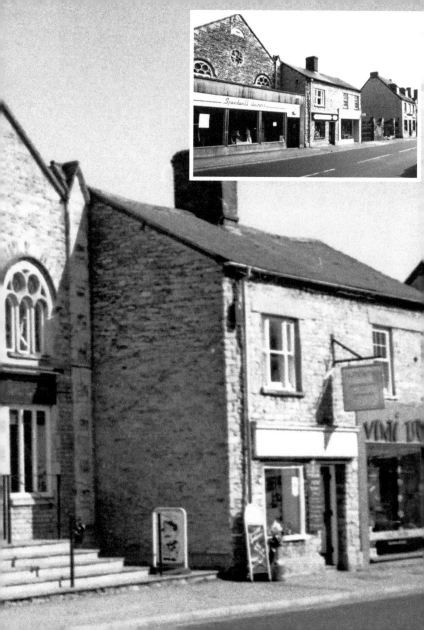

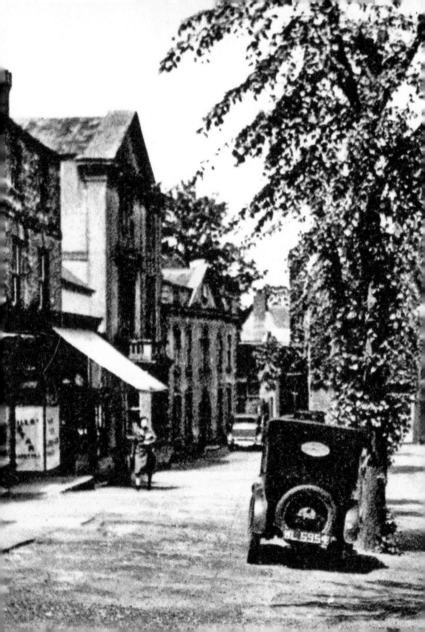

30. THE HILL, MARKET SQUARE

The buildings on the western side of Market Square are higher than their counterparts on the eastern side, insofar as they are sited on a raised terrace known as 'The Hill'. This *c.* 1920 postcard view is looking northwards towards the High Street. No. 2 High Street, formerly the Temperance Hotel and now Boots, can be seen to the right of the picture, together with the Cross Keys Inn.

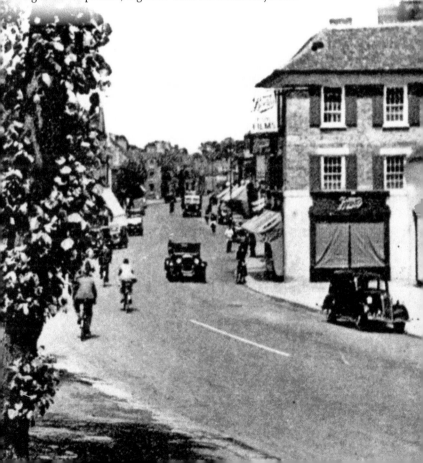

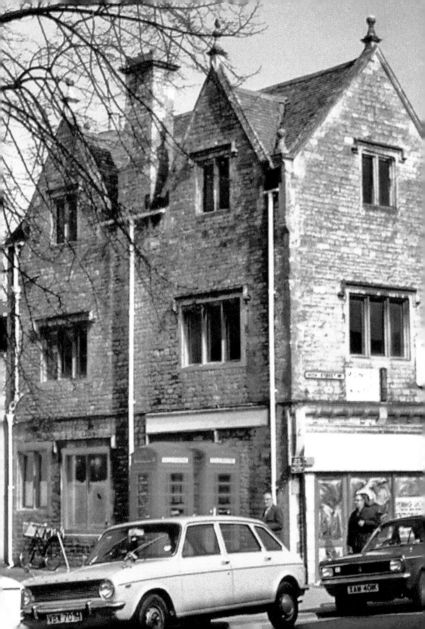

31. PINNACLE HOUSE – THE OLD POST OFFICE

Nos 1, 3 and 5 High Street, now known as 'Pinnacle House'. In later years this picturesque Cotswold stone town house became Witney Post Office, but it is now used as shops and offices. Although the gabled façade hints at a late sixteenth- or early seventeenth-century origin, three of the six front gables are Victorian additions that were added during the nineteenth century.

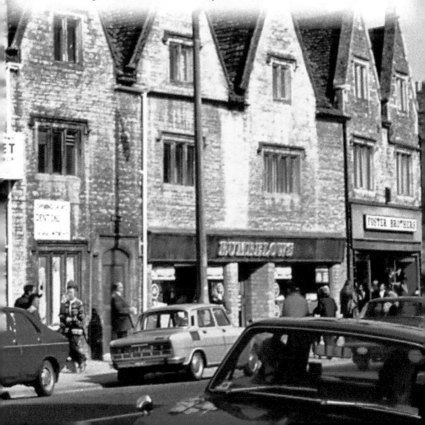

32. THE CONGREGATIONAL CHAPEL, HIGH STREET

Independents (or Congregationalists) have existed in Witney since 1662. The Congregational Chapel in High Street was opened on 1 October 1828, replacing the earlier chapel in Meeting House Lane. The manse at the rear of the chapel was purchased, along with an orchard and gardens, in 1827, the cost of the transaction being £700. Sadly, in 1969, the entire property – both church and manse – was sold to make room for a supermarket. There have been considerable changes on the west side of the street, and at one stage every building between Nos 7 and 29 was threatened with demolition in connection with redevelopment and new road schemes.

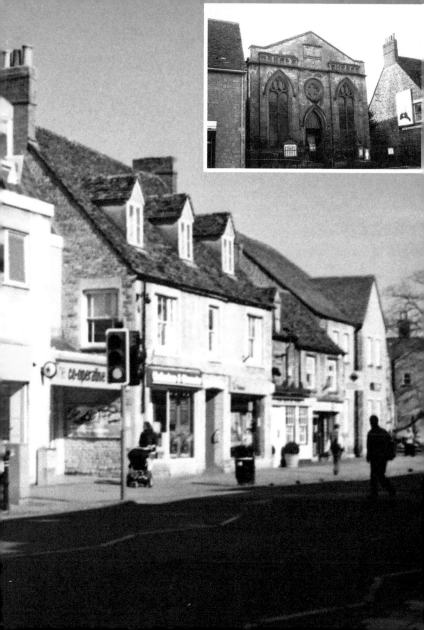

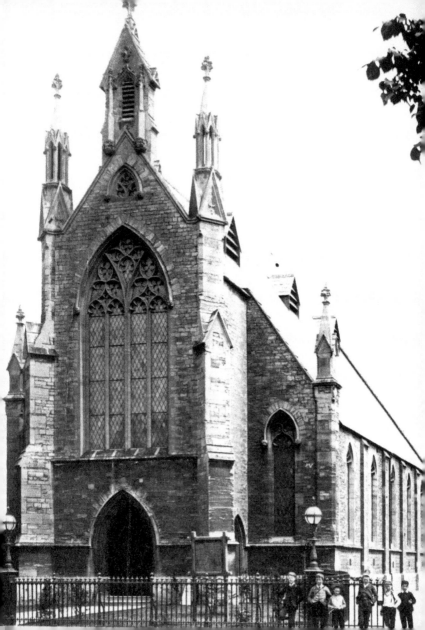

33. THE WESLEYAN CHAPEL & SCHOOL, HIGH STREET

Methodism became particularly strong in Victorian Witney, and on 22 February 1850 a new chapel was opened by the Revd Jabez Bunting, who had inherited John Wesley's role as head of the Methodist Church. Designed by James Wilson of Bath, this new place of worship featured a steeply pitched gable roof, with towering pinnacles and tall Gothic windows. A Wesleyan school was opened at the rear of the chapel in 1851 – the Methodists having rejected the idea of sharing the Anglican schools. By 1853 the Wesleyan school had over 130 pupils, together with one master and two pupil-teachers.

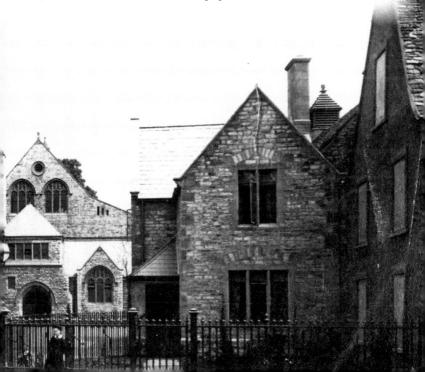

34. WATERLOO HOUSE, HIGH STREET

The building visible towards the right of this *c.* 1890 photograph, Nos 58 and 60 High Street, was known as 'Waterloo House'. It was occupied by G. Osborn Tite and was, for many years, a well-known Witney drapers shop, catering for both ladies and gentlemen. The building is now known as 'Waterloo Walk' and, as such, it forms part of a complex of small shops. No. 56 High Street, on the extreme right, was H. Grey's bakery, but it subsequently became Quelch's greengrocers shop.

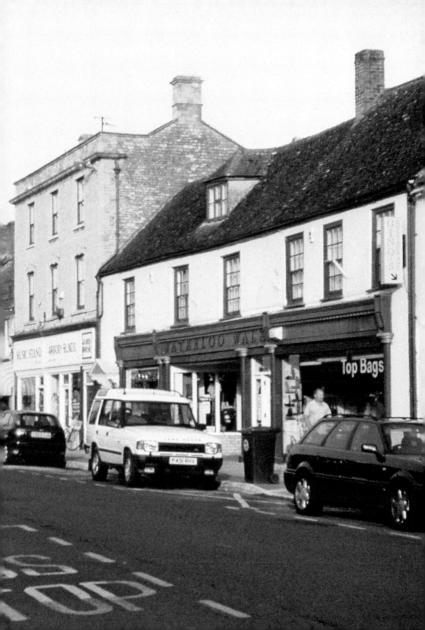

35. CRESSWELL'S YARD –
A WITNEY 'TEWRY'

Cresswell's Yard, on the west side of High Street, contained a row of four cottages and a larger detached house. The cottages visible to the left were numbered 55d, 55c, 55b and 55a. In 1927, No. 55a was the scene of an unexplained fire tragedy in which Mrs Harris was burned to death in her own bed, having apparently made no attempt to escape from the flames. Her young daughter, who was present at the time, was unable to provide any reliable information, although a candle was found near the bed. Yards and alleyways such as Cresswell's Yard were known in Witney as 'tewries'.

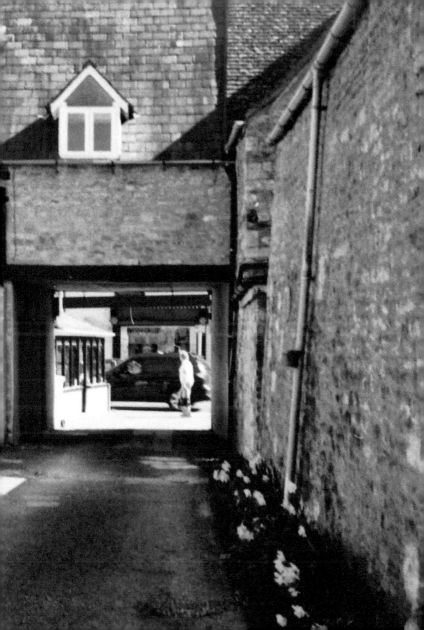

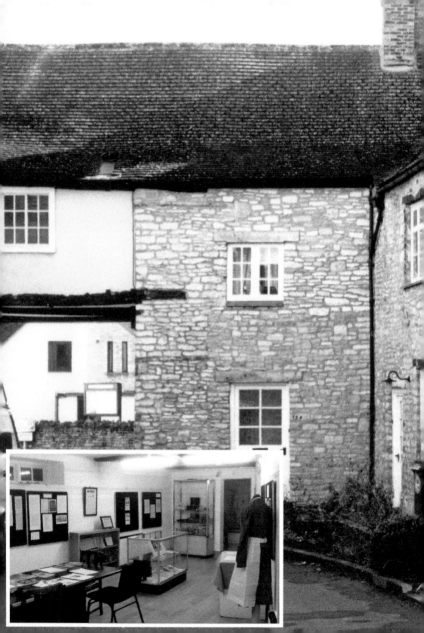

36. THE WITNEY & DISTRICT MUSEUM, HIGH STREET

Opened in 1996, the Witney & District Museum is accommodated in a building at the rear of No. 75 High Street that was formerly occupied by Malachi Bartlett, a prolific local builder, and the founder of a well-known local building firm. The museum contains permanent local history displays on the ground floor, together with an upper gallery (*see* inset) that is used for temporary exhibitions.

37. THE NORTH END, HIGH STREET

The construction of the new roads known as 'Witan Way' and 'Langdale Gate' necessitated the destruction of a several buildings, including the historic Crown Hotel and the Co-operative food store and neighbouring properties at the north end of the High Street. The Council for the Preservation of Rural England was, at that time, deeply concerned about the unnecessary destruction of historic buildings in Witney and the flagrant 'contraventions of planning consent and damaging alterations to listed buildings', which the council allowed to continue.

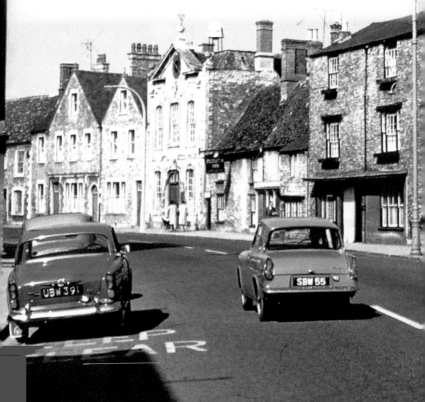

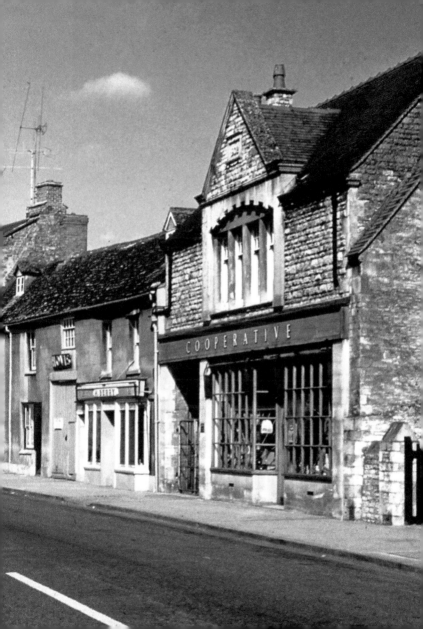

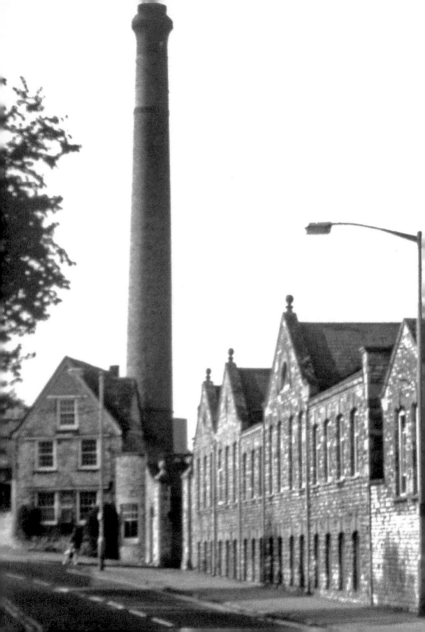

38. WITNEY MILL, MILL STREET

Witney Mill was built on the site of a mill mentioned in the Domesday Book. The two-storey buildings adjacent to the road were erected by William Cantwell in 1888 and rebuilt after a fire in 1905. The 110-foot brick chimney dates from 1895. The mill extended over both sides of Mill Street, a spinning shed being erected on the south side of the road during the 1930s, while further expansion took place after the Second World War. Witney Mill was Witney's last working blanket factory. It was officially closed on 19 July 2002.

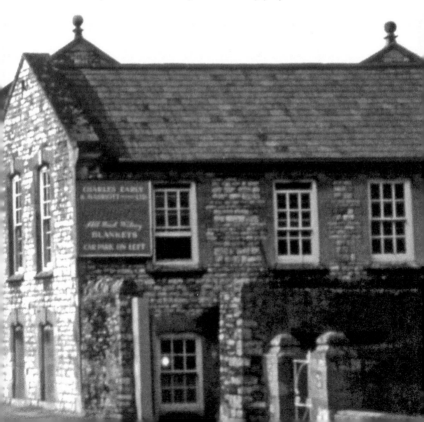

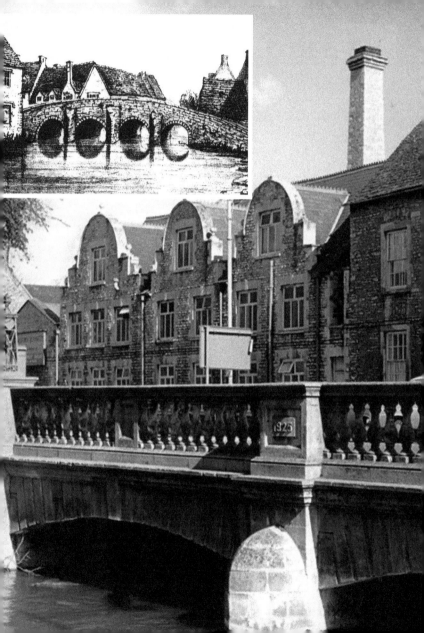

39. THE BRIDGE OVER THE RIVER WINDRUSH, BRIDGE STREET

A view of Witney Bridge around 1975. The flow of water was, at one time, restricted by the narrow apertures of an earlier bridge, resulting in the formation of a small gravel beach, which enabled horses to drink from the river. The bridge was rebuilt with two spans in 1926 and the beach has now disappeared. The inset view shows a much earlier four-arched bridge.

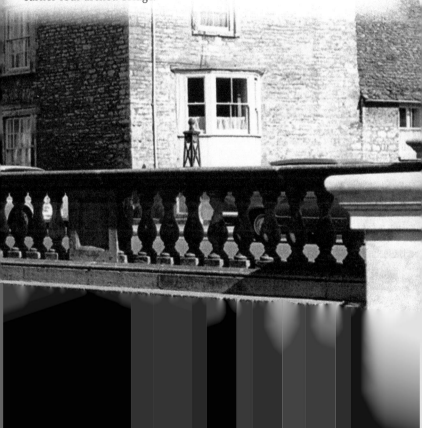

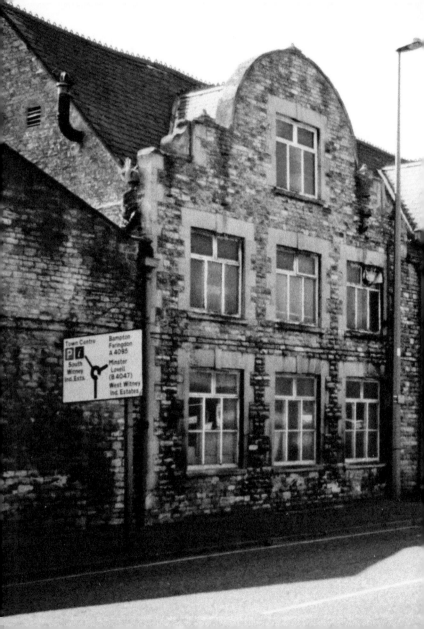

40. BRIDGE STREET MILL

Bridge Street Mill was opened in 1866 by William Smith (1815–75). In 1840 the site of the mill had consisted of several diverse properties including houses, gardens, stables, outbuildings and a national school. As first constructed, the mill was partially hidden behind these older buildings, but the construction of the new façade, with its triple Jacobean-style gables, transformed the appearance of the mill in a most attractive way. The mill was closed in 1975.

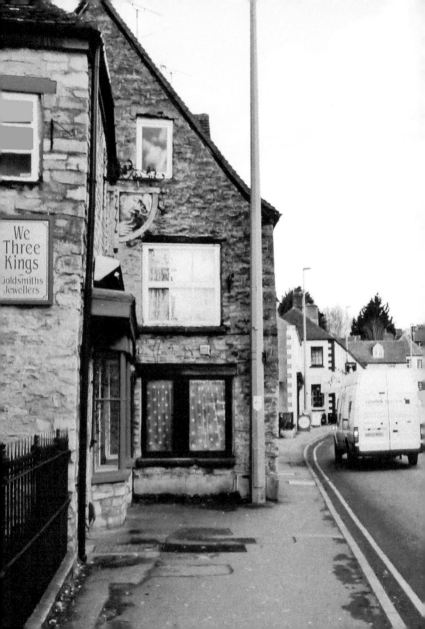

41. BRIDGE STREET, LOOKING NORTH TOWARDS WOOD GREEN

A general view of Bridge Street, looking northwards towards Wood Green in February 2013. In recent years this part of Witney has become associated with the *Thrush Green* novels of Dora Jessie Saint (1913–2012), better known as Miss Read, who is said to have used the town as the prototype for Lulling. Nearby Wood Green, which is linked to Bridge Street by Broad Hill, is thought to have been the inspiration for *Thrush Green*.

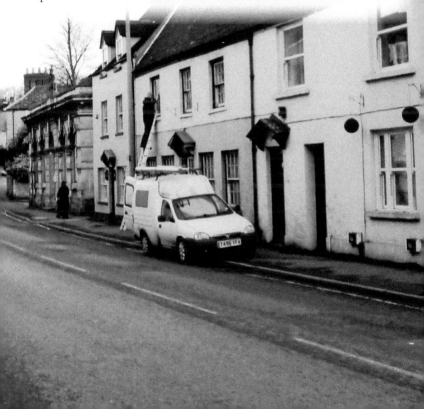

42. WEST END –
THE 'OLD-FASHIONED STREET'

The street known as West End, which runs westwards from Bridge Street, was one of the most populous parts of Victorian Witney, and it was also the site of various blanket factories and weaving shops, including a complex of mainly eighteenth-century buildings at the rear of No. 55. It is interesting to recall that West End was associated with the First World War song 'The Old-fashioned Town', first sung in 1914. The writer of the song, Miss Ada Leonora Harris, used to stay with her aunt and uncle at No. 48 West End – the 'old-fashioned house' referred to in the song.

43. HOLY TRINITY CHURCH, WOOD GREEN

Holy Trinity Church is an Anglican chapel of ease that was built on Wood Green, ostensibly for the benefit of people living at the north end of the town who would 'not have to walk the distance to the Parish Church'. It was designed by Benjamin Ferrey and built in just one year, the foundation stone being laid on 5 May 1848, while the new church was consecrated on Wednesday 11 July 1849 by Samuel Wilberforce, the Bishop of Oxford. The church has been identified with 'St Andrews' in the *Thrush Green* novels.

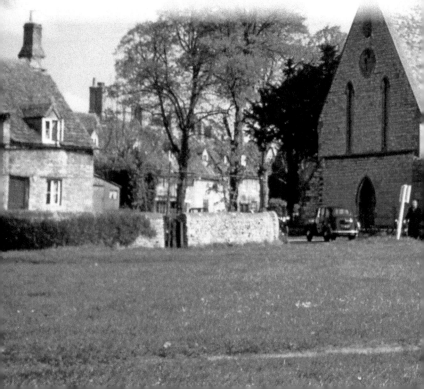

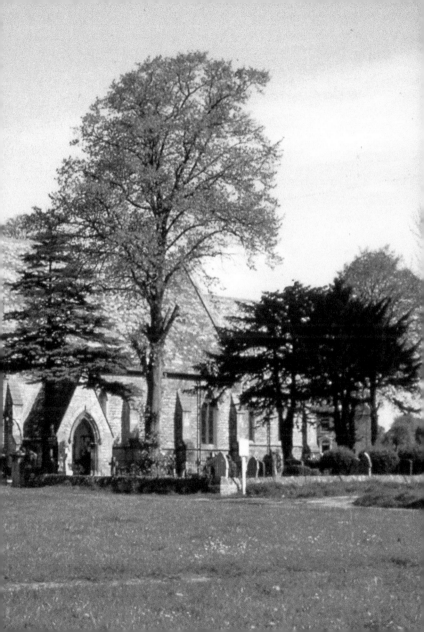

44. ST MARY'S CHURCH, COGGES

Having reached Wood Green, we can now return to central Witney via Newland, Cogges, Langal Common and Crown Lane. Cogges Parish Church, dedicated to St Mary, was once associated with the monks of Fécamp Abbey in Normandy, and this may explain the distinctly French appearance of its unusual tower, which has octagonal upper stages and a pyramidal roof. The building consists of a nave, aisles, chancel, south porch and tower.

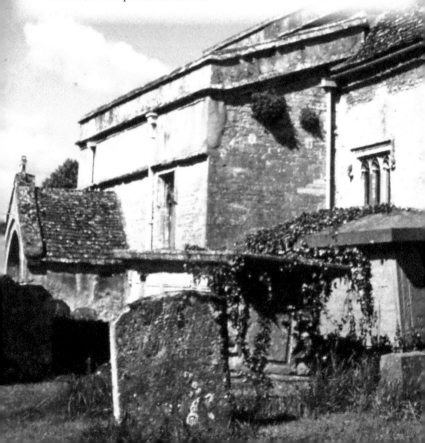

45. COGGES VILLAGE

This *c.* 1970s photograph shows part of Cogges village, the former Blake School being visible to the left, while Cogges Priory can be seen to the right of the picture. The footpath in the foreground is a public right of way between Newland and Cogges, while the pathway that can be seen running from east to west in the distance links up with Crown Lane on the west side of the Windrush. A 'Norcon' pattern concrete pipe pillbox, dating from 1940, can be seen in the left foreground – though it is hard to imagine what use this would have been in the event of a German invasion!

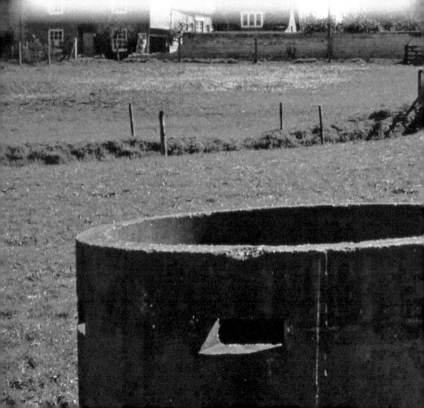

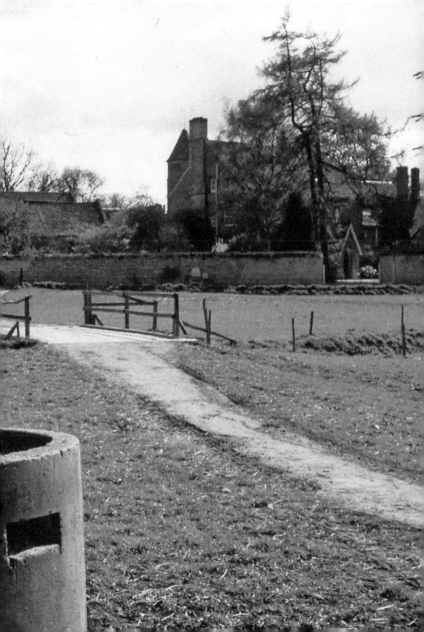

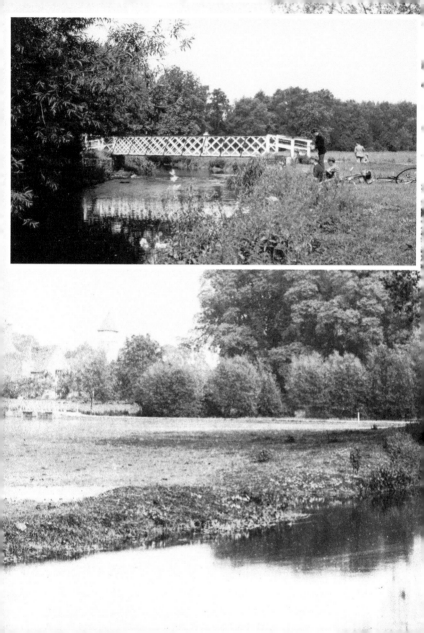

46. THE RIVER WINDRUSH, LANGAL COMMON

After passing beneath Witney Bridge, the river splits into two streams, the open space between the two channels being known as Langal (or 'Langel') Common. In Edwardian days, the gardens of houses on the east side of High Street extended down to the riverbank, and some householders kept skiffs or punts for use during the summer months. Crown Lane crosses Langal Common at right angles, necessitating footbridges across both branches of the river (*see* inset). Continuing westwards, pedestrians follow the surviving section of Crown Lane, which merges with Witan Way as it approaches Market Square and the starting point of the tour on Church Green.

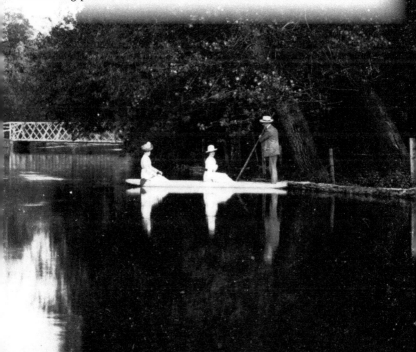

STANLEY C. JENKINS

WITNEY

THROUGH TIME

This fascinating selection of photographs traces some of the many ways
in which Witney has changed and developed over the last century.
978 1 4456 0949 2
Available to order direct 01453 847 800
www.amberley-books.com